The Doubtful Guest

by Edward Gorey

DEY ST.
AN IMPRINT OF
WILLIAM MORROW *PUBLISHERS*

www.harpercollinschildrens.com

Library of Congress Cataloging-in-Publication Data
Gorey, Edward, 1925–2000
The doubtful guest/Edward Gorey.
p. cm.
Originally published: New York : Peter Weed Books, 1957.
ISBN 978-0-15-100313-6
I. Title.
PS3557.0753D68 1998 98-15382
813′.54—dc21

23 RRDA 30 29 28 27 26 25

Printed in Vietnam

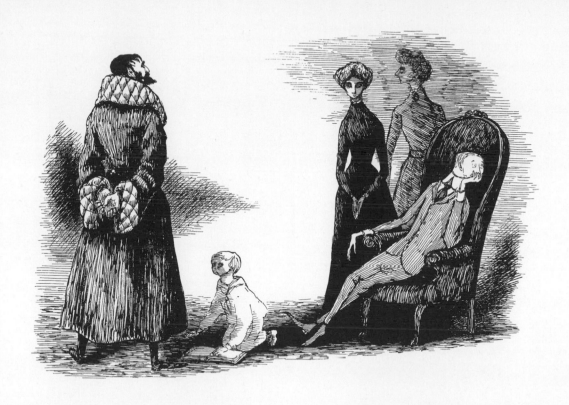

When they answered the bell on that wild winter night,
There was no one expected – and no one in sight.

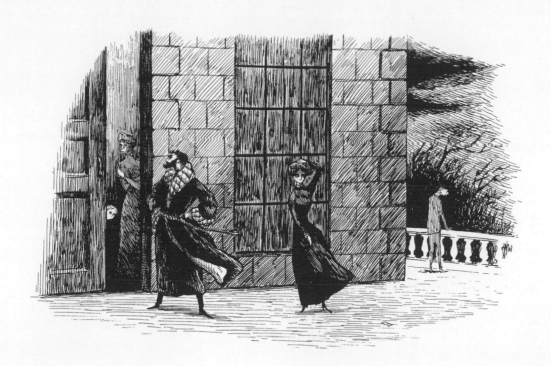

Then they saw something standing on top of an urn,
Whose peculiar appearance gave them quite a turn.

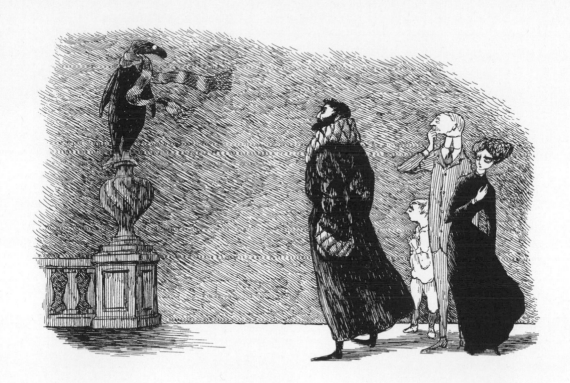

All at once it leapt down and ran into the hall,
Where it chose to remain with its nose to the wall.

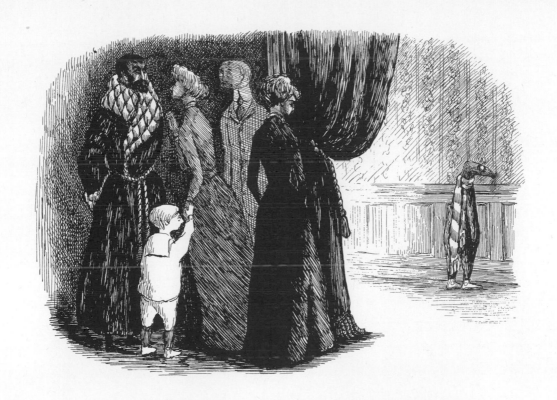

It was seemingly deaf to whatever they said,
So at last they stopped screaming, and went off to bed.

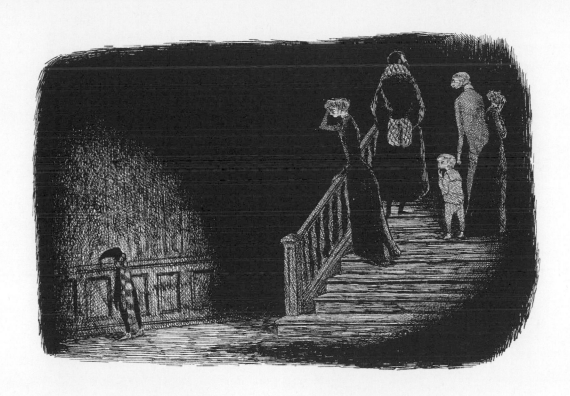

It joined them at breakfast and presently ate
All the syrup and toast, and a part of a plate.

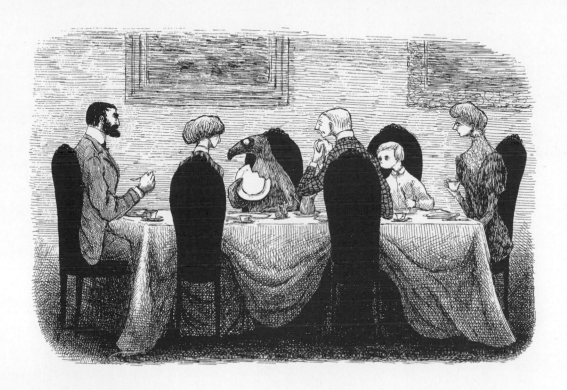

It wrenched off the horn from the new gramophone,
And could not be persuaded to leave it alone.

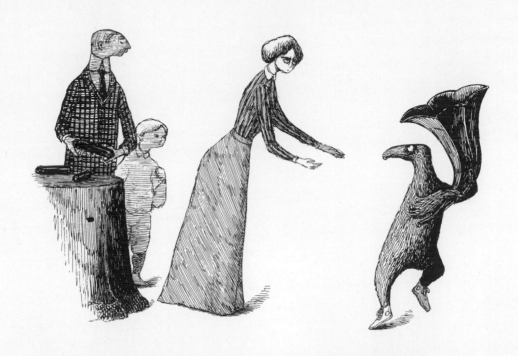

It betrayed a great liking for peering up flues,
And for peeling the soles of its white canvas shoes.

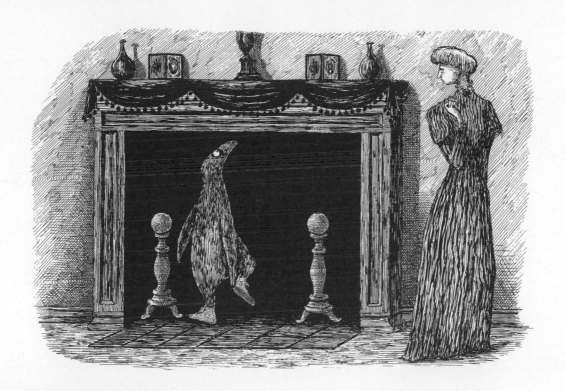

At times it would tear out whole chapters from books,
Or put roomfuls of pictures askew on their hooks.

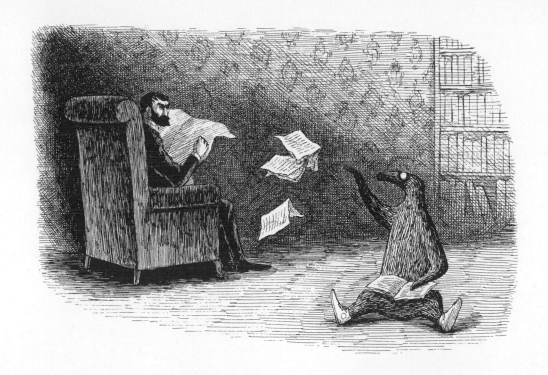

Every Sunday it brooded and lay on the floor,
Inconveniently close to the drawing-room door.

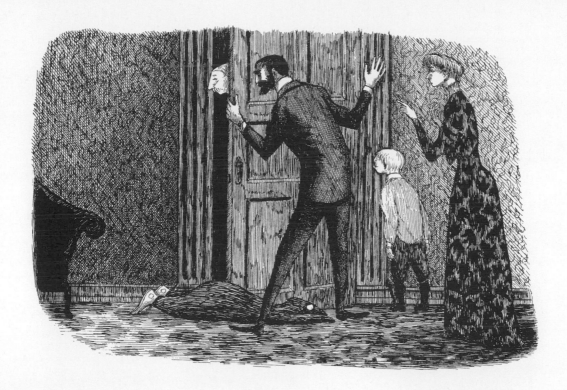

Now and then it would vanish for hours from the scene,
But alas, be discovered inside a tureen.

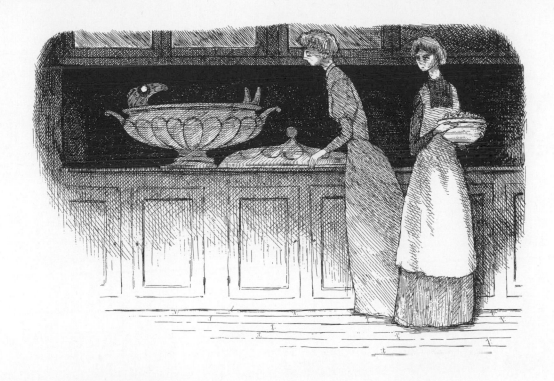

It was subject to fits of bewildering wrath,
During which it would hide all the towels from the bath.

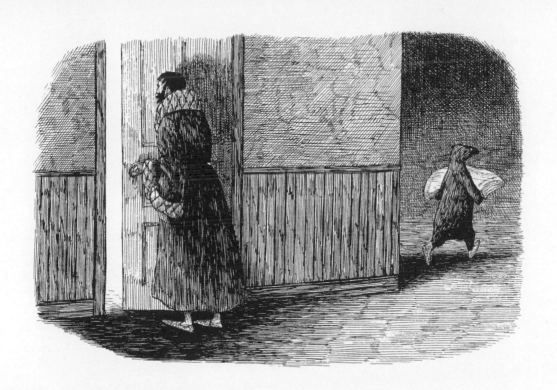

In the night through the house it would aimlessly creep,
In spite of the fact of its being asleep.

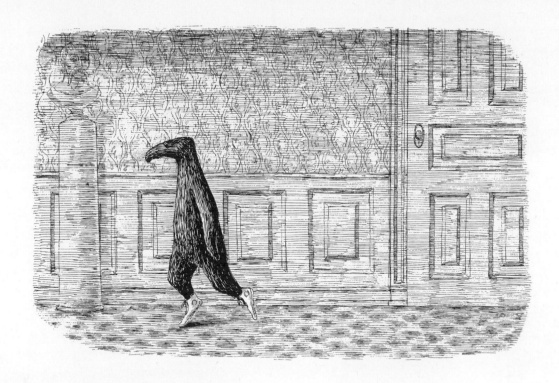

It would carry off objects of which it grew fond,
And protect them by dropping them into the pond.

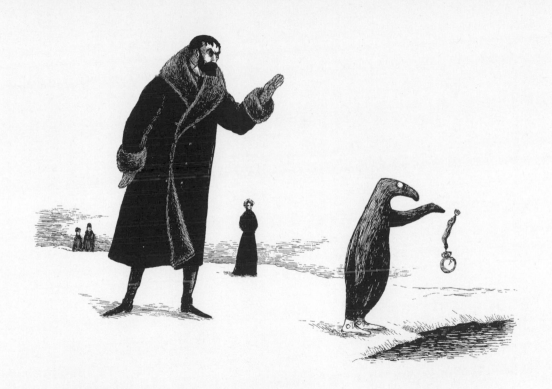

It came seventeen years ago – and to this day
It has shown no intention of going away.

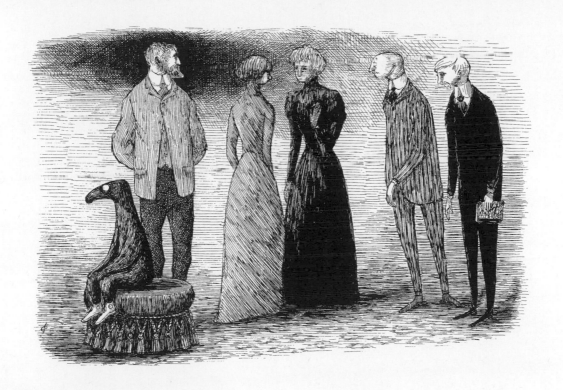